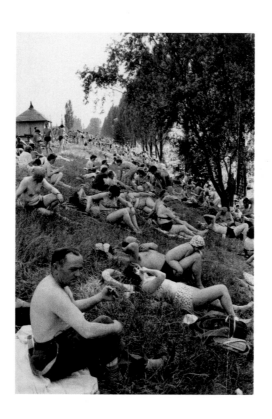

MAIRA KALMAN

DANIEL HANDLER

WEATHER, WEATHER

Series Editor
Sarah Hermanson Meister

The Museum of Modern Art
New York

I was in my room wondering what
it was like somewhere else.

What's the weather like?

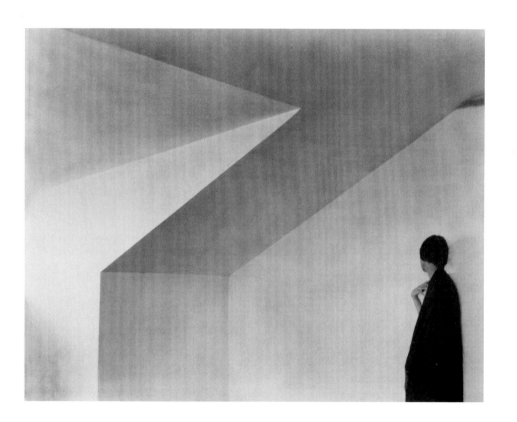

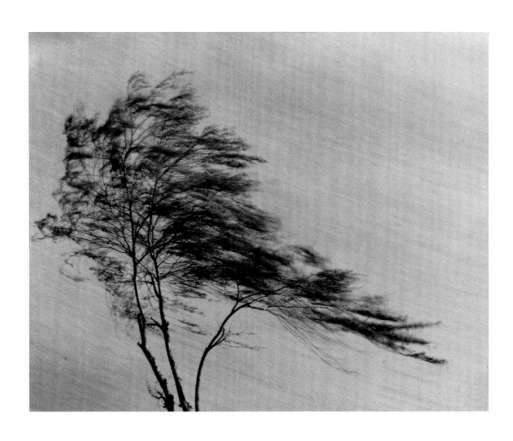

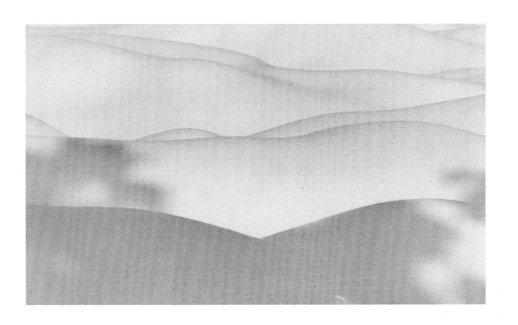

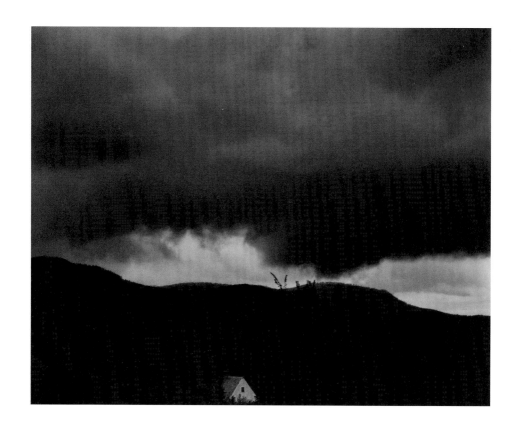

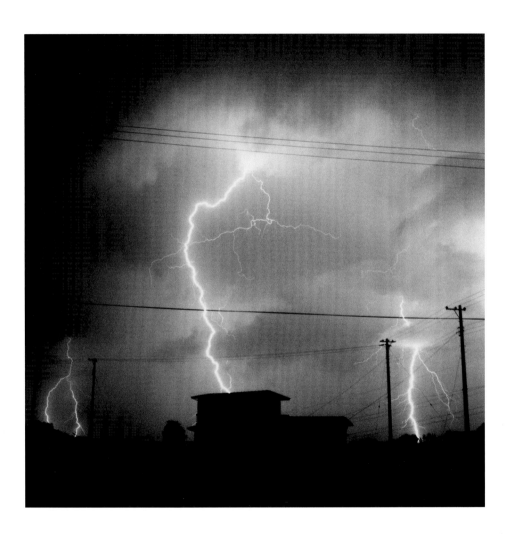

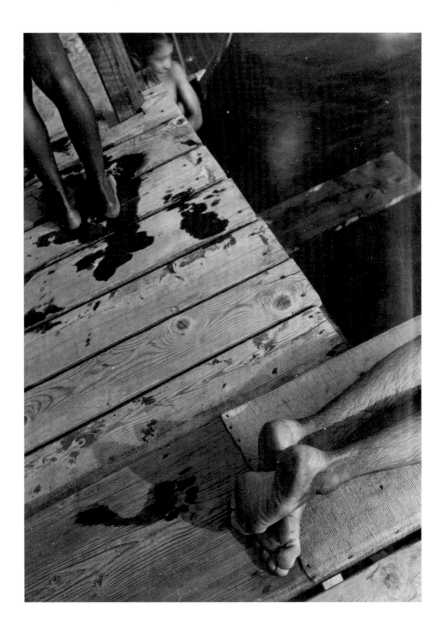

It's like summer. It's like doing nothing.

Delicious.

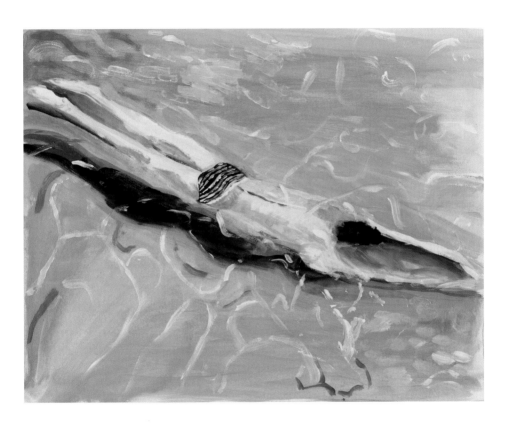

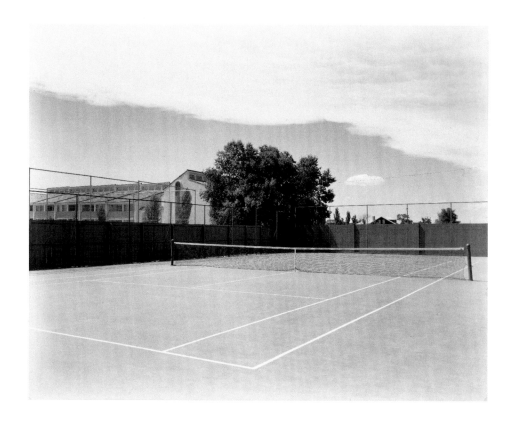

It's like a day so hot you can't do anything
but say how hot it is.

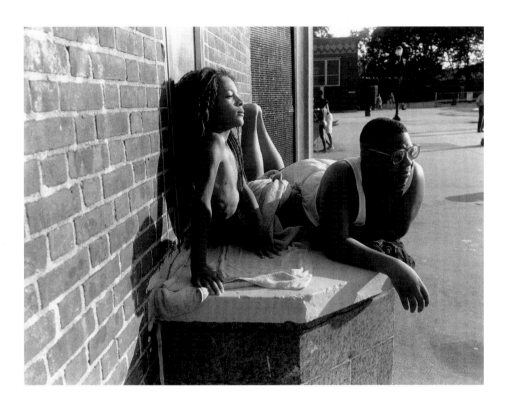

It's like looking around and trying
to figure out what it's like.

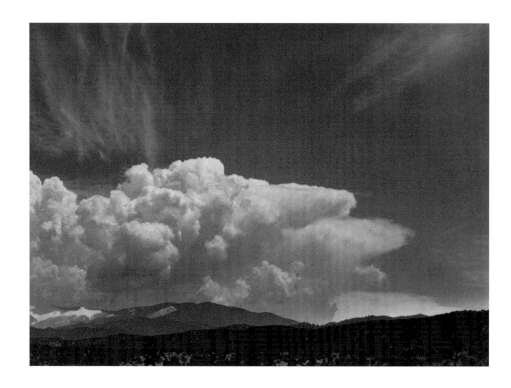

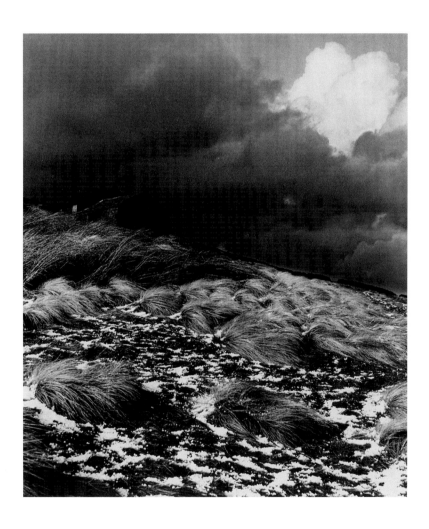

It might change. Of course it will.

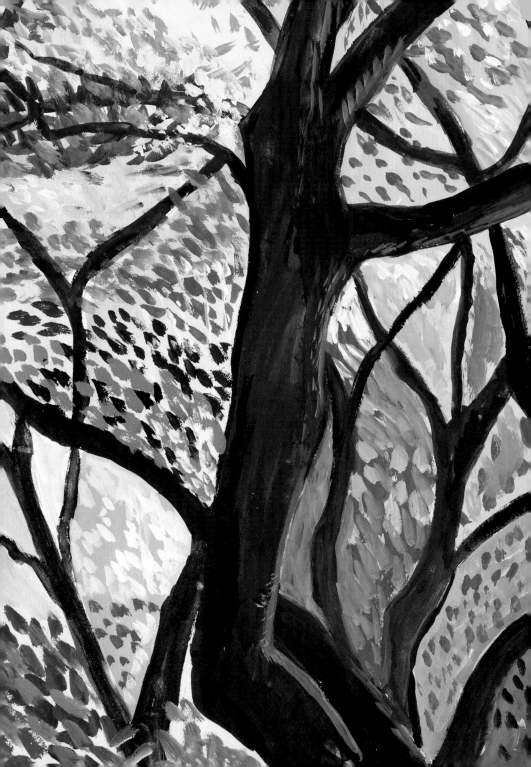

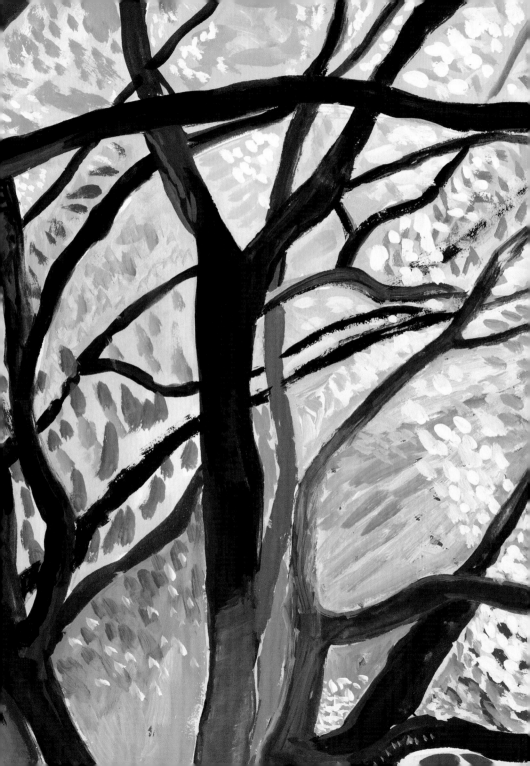

It's cold, it's cold.

How could they let it get as cold as this?

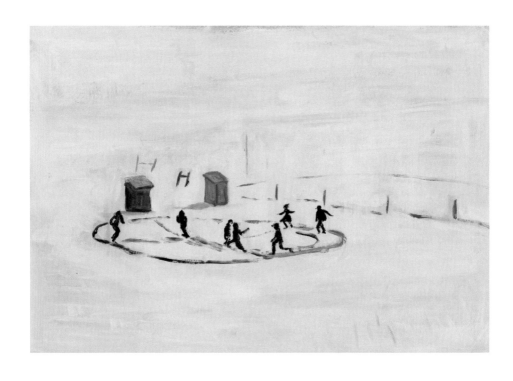

When it's cold you can look at
your own breathing.

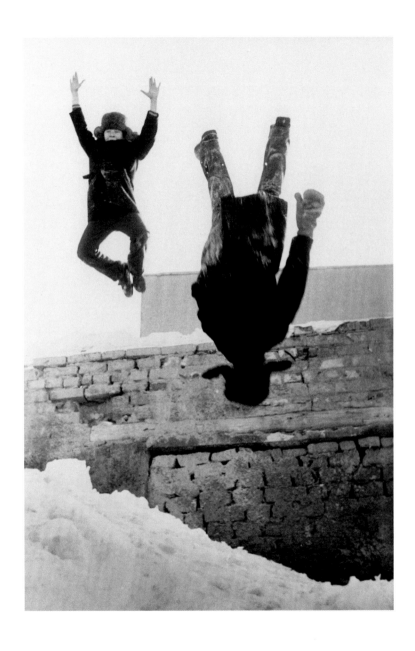

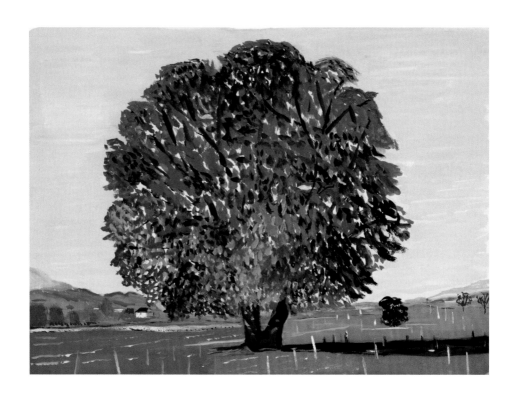

Remember that summer?
Spring, I mean?

It's like that.

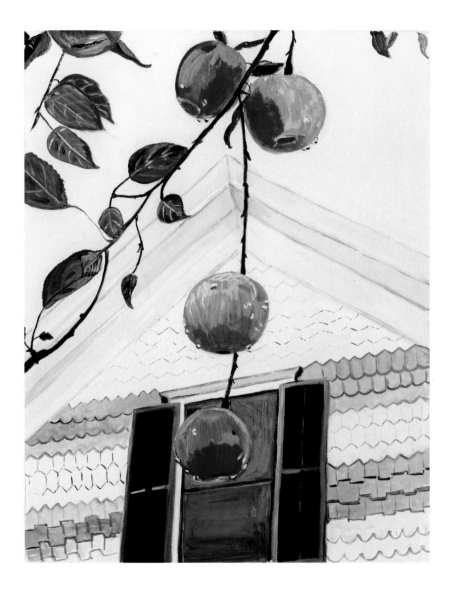

I didn't notice what it was like.

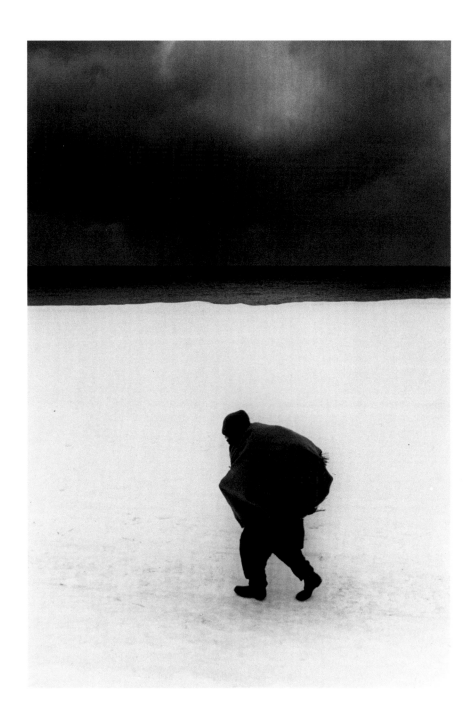

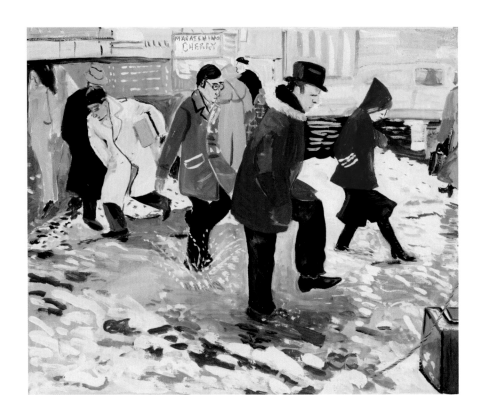

It looks cold out there.
It looks wet.

Bring something with you.

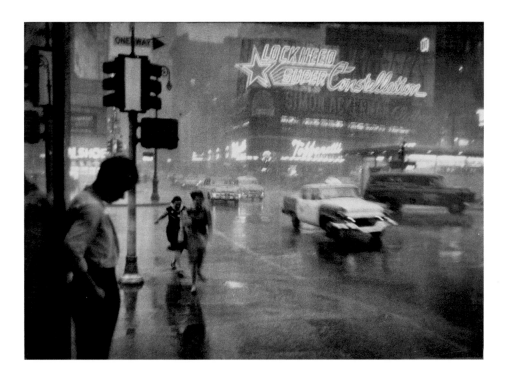

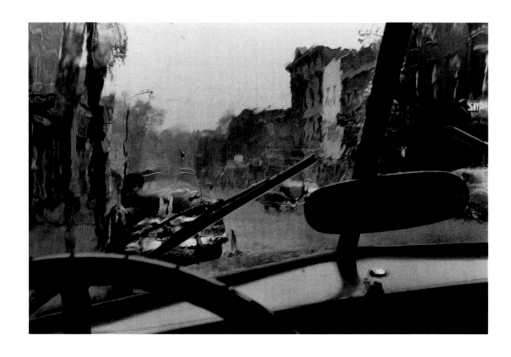

They said there was a chance of
storms and here it is storming.

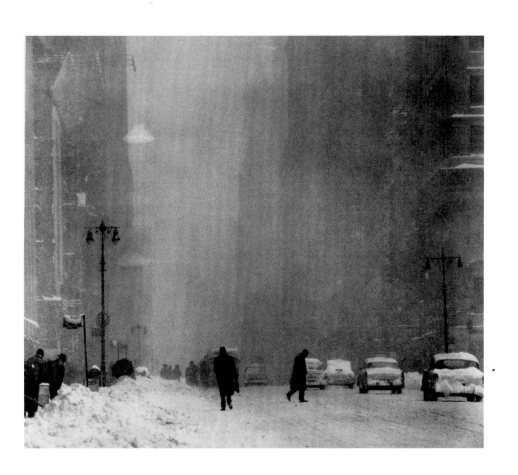

I guess there's always a chance.

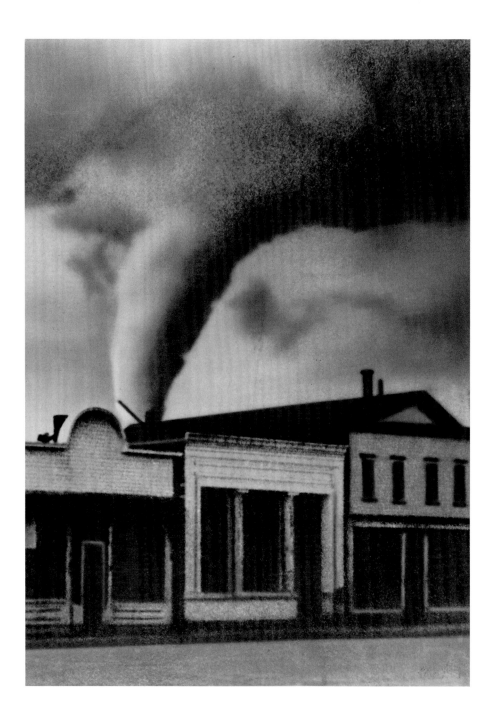

The newspaper said it would
be nice today.

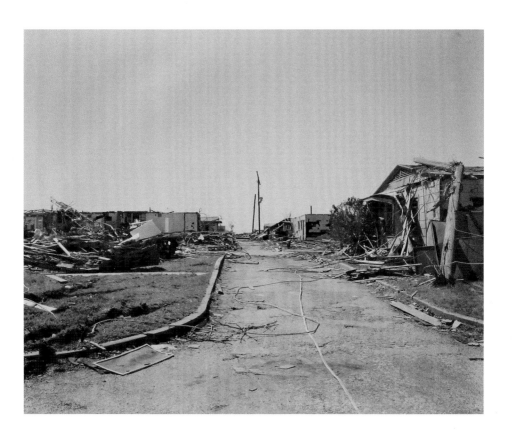

What does the newspaper know.

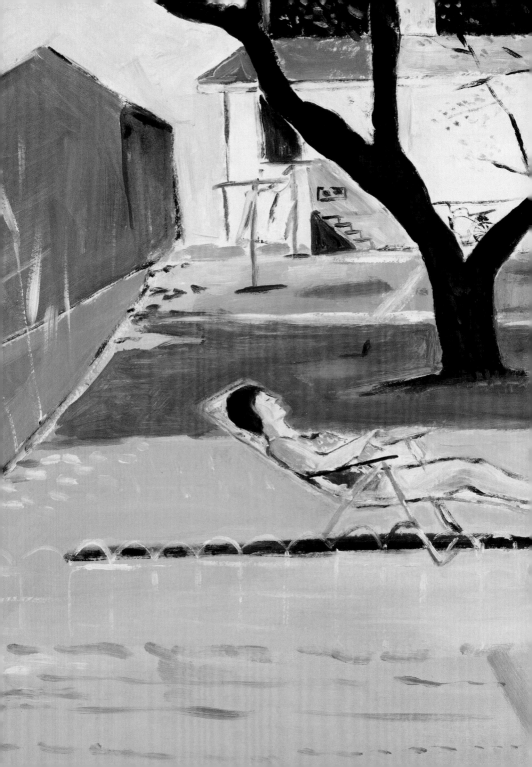

One nice thing about looking at
the sky is that you know it's not looking
at you.

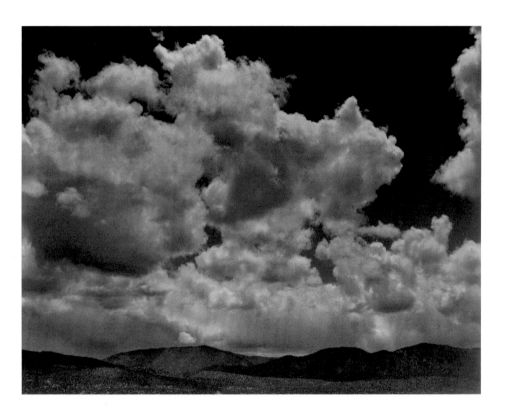

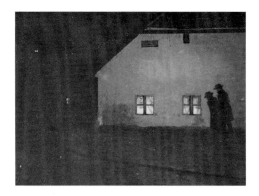

Do you take a walk like you take a pill?
or
Do you take a walk like you take a cookie?

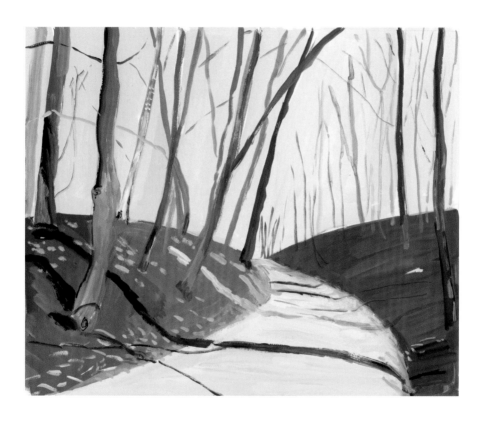

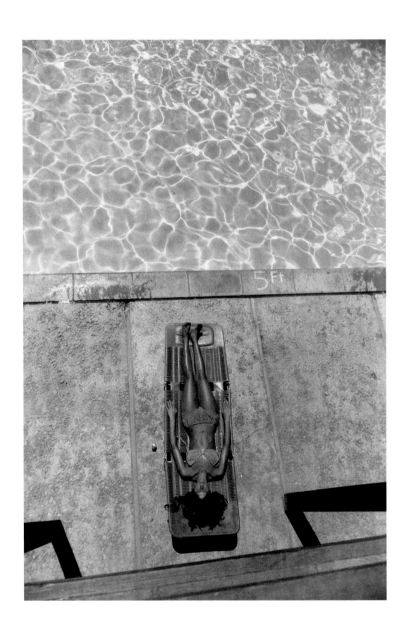

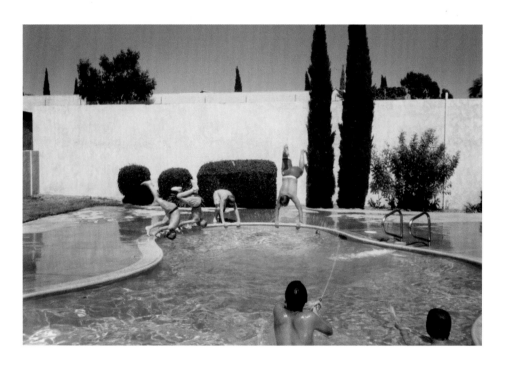

Get some sun, they say.
Go out and get some sun.

We're revolving around it,
might as well get something
out of it.

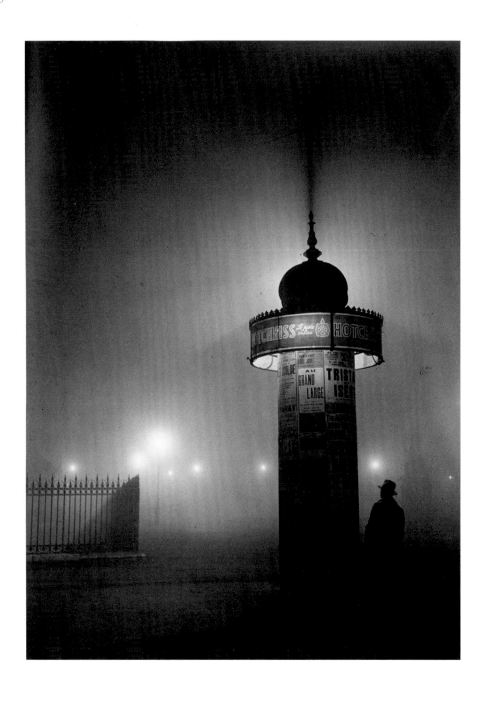

When it's dark you can't see three feet in front of you.

But that's not why you're out here in the dark. Is it.

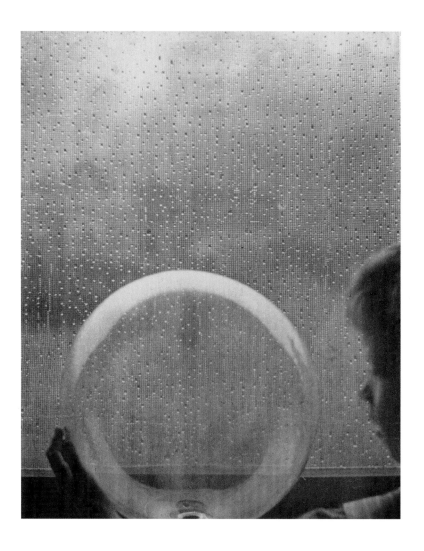

Tell us what it's like where you are.

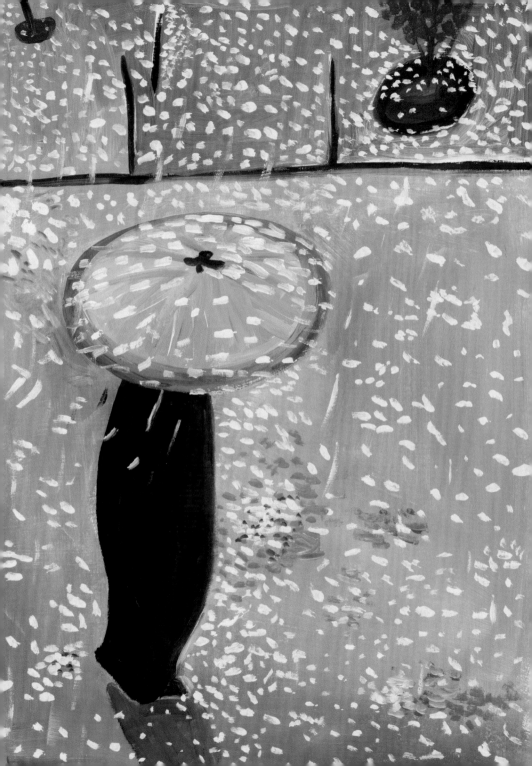

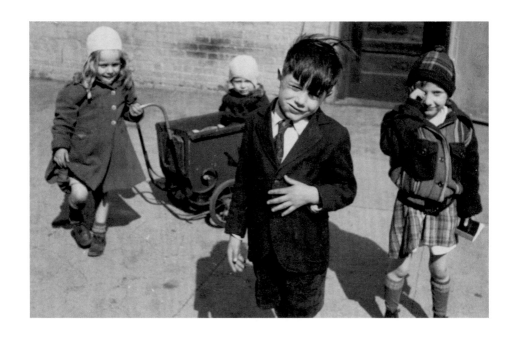

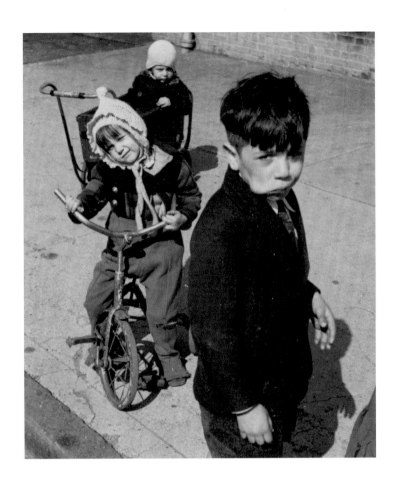

What we mean is, we know what it's like
in our neighborhood.

We know what it's like where we are.

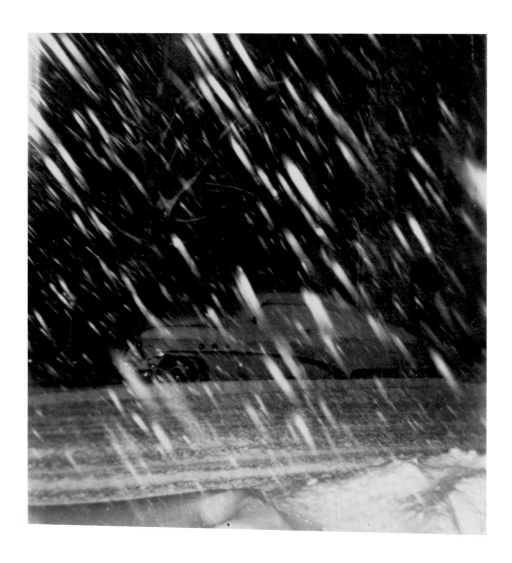

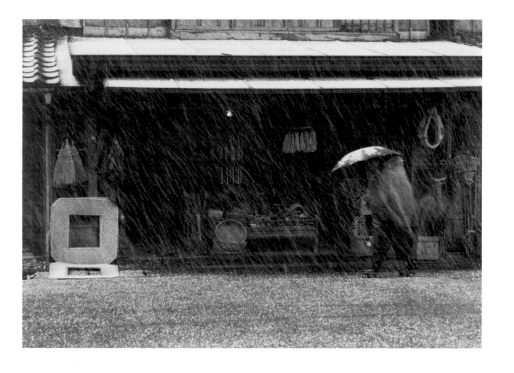

How can we know what it's like,
unless you tell us?

You don't have to tell us
everything, but tell us what the
weather is like.

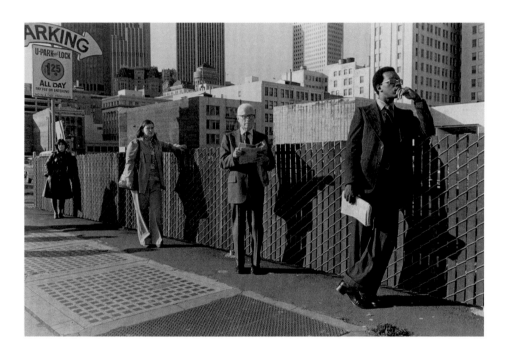

You call someone from far away and they say,
what's the weather like?

You say it's nice. You say it's cold.

You say you wouldn't believe how hot,
how cold. I miss you.

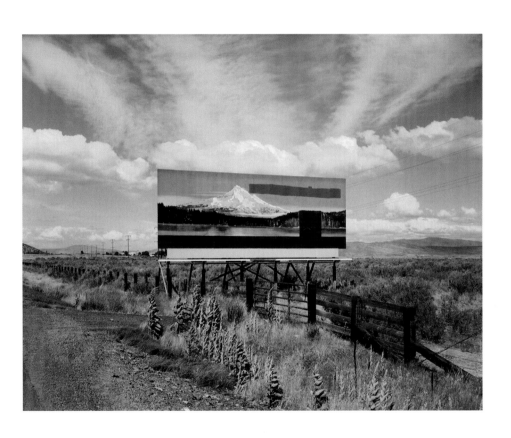

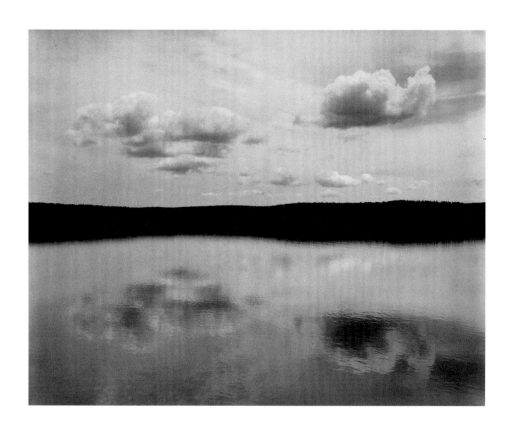

It's great out there.
Let's call it the Great Outdoors.

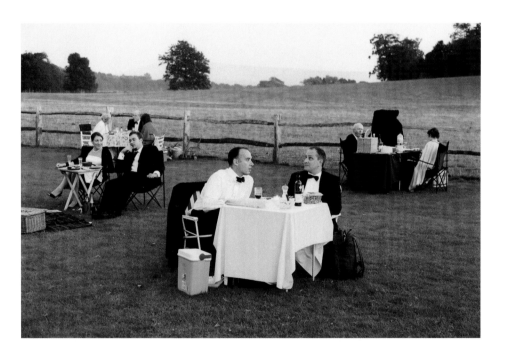

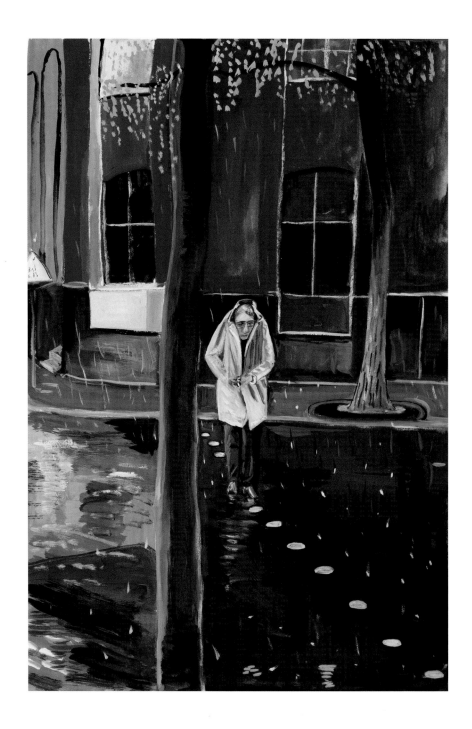

I can't even say what it's like.
It's perfect, the whole thing.
Come with me, take me
with you. Let's go out together
and have poached eggs.

Delicious.

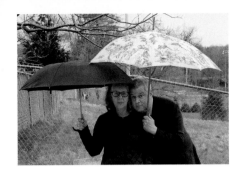

It was a coup de foudre.
I hadn't the foggiest notion what to do.
We were breaking the ice.
We were on cloud nine.
Everything was right as rain.
And then, out of the clear blue sky,
there were stormy looks.
Are you under the weather?
Why the tempest in a teacup?
Soon the clouds will part.
Blue skies. Clear sailing.
It is the weather, after all.
— M. K.

I grew up in a place of hardly varying weather. We did not
talk about it, because there was nothing to talk about.

I fell in love with a woman from a land where the weather
changes seasonally and dramatically. Everyone talks about it
all of the time. I had never see this before, and I did not
know what to do.

"But doesn't it get cold every year?" I asked. "Why are we
talking about it as if it is the end of the world?"

My sister set me straight. She married a man from a similar
land, after studying anthropology. "Daniel," she said—
she calls me Daniel—"You must think of it as an elaborate
ceremony, like having tea with an emperor. You don't just
gulp the tea. There are things you must do first. Daniel,
you must talk about the weather."

Everything is fine now. I married the woman, and her
family calls us. "Is it cold?" I ask. "Is it hot? Is it raining? Is it
snowing? What is the weather like?" And they tell me.
— D. H.

A picture may be worth a thousand words, but it's striking how often those pictures are accompanied by even more words: a title or caption that complicates or clarifies what we see in the photograph. This book is the third in a series of collaborations between Daniel Handler and Maira Kalman, using photographs from the collection of The Museum of Modern Art as points of departure. In the first of these books, *Girls Standing on Lawns*, three-quarters of the photographs

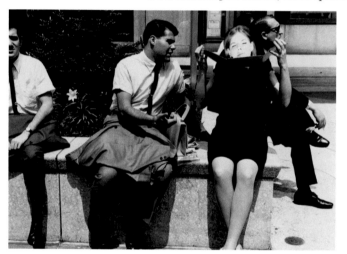

are untitled; for all but one of those with titles, the title simply identifies the person in the picture (*Agnes Hambrick, Mrs. Northup*, or *Leta, the day she left for Lex*). All of the photographs in the first book are snapshots, and they served a very particular and personal purpose—to document a loved one, or a friend, or a special occasion—although the names of the people who made them (and many of the people who posed in them) are unknown to us now.

We know the names of the photographers who made almost every image included in the second book from this series, *Hurry Up and Wait*, and most of the photographers were making images they considered to be works of art. Some are

untitled, many give a brief description or a location as a title, and a few complement their work with a poetic or dramatic phrase (*Leap into the Void*). Perhaps because their work is often tied so closely to what you can observe in the real world, photographers generally prefer to have you look at their photographs and come to your own conclusions rather than give you too much information at the start: they know how profoundly words can affect your interpretation of what you are seeing. The exceptions to this rule are photographers who work for newspapers or news agencies: for them information is essential, and they want to make sure they provide it up front. There are three examples of this in the book you are holding (they appear on pages 26, 27 and 30), and they all have detailed, lengthy captions that were provided on the backs of the prints.

In each book from this series, Maira makes paintings that are inspired by photographs in MoMA's collection: whether or not the original images are black and white, in her renderings she selects whatever color she likes from her palette. And in each book Daniel writes a prose poem to accompany the paintings and photographs: we provide the original titles at the back of each volume (just in case you're curious), but these are irrelevant to his purpose. He chooses his words very carefully to tell a story that—in conjunction with the pictures—might just change the way you think about the weather.

Sarah Hermanson Meister
Curator, Department of Photography
The Museum of Modern Art, New York

The Photographs

All works are in the collection of The Museum of Modern Art, New York.
Except where noted, they are gelatin silver prints. The dimensions correspond
to the image size, with height proceeding width.

Cover and page 1
Dan Weiner
(American, 1919–1959)
Sunbathers,
Czechoslovakia. 1957.
13¼ × 8⅞" (33.6 ×
22.6 cm). Gift of
Sandra Weiner

Page 5
Edward Weston
(American, 1886–1958)
Attic. 1921. Palladium
print, 7⁷⁄₁₆ × 9⁷⁄₁₆"
(18.9 × 23.9 cm).
Thomas Walther
Collection. Grace M.
Mayer Fund and gift of
Mrs. Mary Donant
and Carl Sandburg,
by exchange

Page 6
Chuji Yao
(Japanese)
Wind. c. 1955. 8 ×
10⅛" (20.3 × 25.5 cm).
Gift of Nihon Keizai
Shimbun

Page 7
Shoji Ueda
(Japanese, 1913–2000)
Snow Surface. c. 1958.
8⁵⁄₁₆ × 13¾" (21.1 x
35 cm). Gift of Nihon
Keizai Shimbun

Page 8
Alfred Stieglitz
(American, 1864–1946)
Music—A Sequence of
Ten Cloud Photographs,
No. 1. 1922. 7⁹⁄₁₆ ×
9½" (19.2 × 24.2 cm).
Thomas Walther
Collection. Gift of
David H. McAlpin and
Alfred Stieglitz, by
exchange

Page 9
Akihide Tamura
(Japanese, born 1947)
June 22, 1968. 1968.
6 × 6" (15.2 × 15.2 cm).
Gift of the artist

Page 10
László Moholy-Nagy
(American, born Hungary.
1895–1946)
The Diving Board.
c. 1931. 11⅛ × 8⅛"
(28.3 × 20.7 cm).
Anonymous gift

Page 11

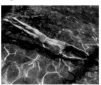

André Kertész
(American, born Hungary.
1894–1985)
Man Diving, Esztergom.
1917. 7¾ × 9⅝"
(19.7 × 24.4 cm).
Purchase

Page 12
Nicholas Nixon
(American, born 1947)
Northeast Court,
Tennis Club of
Albuquerque. August
1973. 7¹¹⁄₁₆ x 9⅝"
(19.6 x 24.5 cm).
Purchase

Page 13
Thomas Roma
(American, born 1950)
Sunset Park, Brooklyn,
New York. 1991.
9⅞ × 12¹⁵⁄₁₆" (25.1 ×
32.9 cm). The Fellows
of Photography Fund

Page 14
Alma Lavenson
(American, 1897–1989)
Clouds, New Mexico.
1940. 7 × 9⅝" (17.8 ×
24.4 cm). Photography
Purchase Fund

Page 15
Bill Brandt
(British, born Germany.
1904–1983)
Top Withens, West
Riding, Yorkshire. 1945.
9³⁄₁₆ × 7¾" (23.3 ×
19.7 cm). Acquired
through the generosity
of Clarissa Alcock
Bronfman and Richard
E. Salomon

Pages 16–17

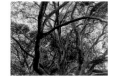

Dorothea Lange
(American, 1895–1965)
Sunlit Oak. c. 1957.
30⅞ × 41⅛" (78.4 ×
104.5 cm). Purchase

Pages 18 and 19, clockwise
from top left
Harry Callahan
(American, 1912–1999)
Objects in Snow. 1947.
2⁵⁄₁₆ × 2³⁄₁₆" (5.8 ×
5.5 cm). Purchase
Objects in Snow. 1947.
2⁵⁄₁₆ × 2³⁄₁₆" (5.8 ×
5.5 cm). Purchase
Objects in Snow. 1947.
2¼ × 2³⁄₁₆" (5.7 ×
5.5 cm). Purchase
Objects in Snow. 1947.
2⅛ × 2³⁄₁₆" (5.4 ×
5.5 cm). Purchase

Page 20

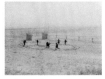

John Vachon
(American, 1914–1975)
Children Playing in
Snow. 1940. 9½ ×
12¹⁵⁄₁₆" (24.1 × 33 cm).
Gift of the artist

Page 21
Valery Shchekoldin
(Russian, born 1946)
Uliyanovsk. 1978. 11⅛ ×
7⅜" (28.2 × 18.8 cm).
The Family of Man
Fund

Page 22

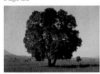

Carleton E. Watkins
(American, 1829–1916)
*Arbutus Menziesii,
California.* 1861.
Albumen silver print,
14⅜ × 21⁷⁄₁₆" (36.5 ×
54.5 cm). Purchase

Page 23

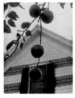

Alfred Stieglitz
(American, 1864–1946)
*Apples and Gable, Lake
George.* 1922. 4½ ×
3⅝" (11.5 × 9.2 cm).
Anonymous gift

Page 25
Hiroshi Hamaya
(Japanese, 1915–1999)
*Woman Hurrying on the
Snow Road, Tsugaro,
Japan.* 1956. 11½ ×
7⅞" (29.2 × 20 cm). Gift
of the artist

Page 26

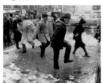

Barney Ingoglia/
The New York Times
(American, born 1928)
*Rain Raises Fears of
Flooding: Pedestrians in
Times Square Wading
through a Puddle as
Heavy Rains Began
Yesterday. The Rain Was
Expected to Continue
Today, Melting Much of
the Snow and Causing
Fears of Flooding.*
January 25, 1978.
7¹⁵⁄₁₆ × 10" (20.3 ×
25.4 cm). The New York
Times Collection

Page 27
Carl T. Gosset Jr./
The New York Times
(American, 1924–1985)
*This Photo Was Made
Just before 4 P.M.
at Broadway and 43rd
Street, Looking East
across Times Square.*
July 24, 1959. 7¹⁵⁄₁₆ ×
11¼" (20.3 × 28.6 cm).
The New York Times
Collection

Page 28
Louis Stettner
(American, born 1922)
*Windshield, Saratoga
Springs, New York.*
1957. 16¹⁄₁₆ × 18⅛"
(40.8 × 46 cm). Gift of
the artist in honor
of David Stettner

Page 29
Andreas Feininger
(American, born France.
1906–1999)
Big Snow, 42nd Street.
1956. 10¼ × 11¾"
(26 × 29.8 cm). Gift of
the artist

Page 30
International News
Photo
*The Portent of Coming
Disaster: A Tornado,
Photographed as
It Moved across the Sky
toward White, S.D.,
by a Cameraman Who
Was the Only Person
Who Did Not Take
Shelter in a Cyclone
Cellar. None of the
Buildings Shown in the
Picture Was Damaged,
as They Were Not
in the Direct Path of the
Tornado.* 1938. 12⅛ ×
9" (30.8 × 22.9 cm).
The New York Times
Collection

Page 31
Frank Gohlke
(American, born 1942)
*Southmoor Manor
Apartments–Looking
South,* from the
series Aftermath:
The Wichita Falls
Tornado. April 14, 1979.
14⁵⁄₁₆ × 17⁹⁄₁₆" (36.3 ×
44.7 cm). Extended
loan from Warner
Communications, Inc.

Pages 32 and 33

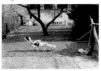

Henry Wessel, Jr.
(American, born 1942)
Untitled. 1968. 9 ×
13½" (22.9 × 34.3 cm).
Purchase

Page 35
Ansel Adams
(American, 1902–1984)
New Mexico. 1933.
7¼ × 9½" (18.4 ×
24.1 cm). Gift of Albert
M. Bender

Page 36
André Kertész
(American, born Hungary.
1894–1985)
Bocskay-tér, Budapest.
1914. 1⁷⁄₁₆ × 2¹⁄₁₆"
(3.7 × 5.2 cm). Thomas
Walther Collection.
Gift of Thomas Walther

Page 37

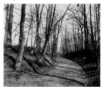

Eugène Atget
(French, 1857–1927)
Saint-Cloud. 1923.
Albumen silver print,
6⅞ × 8⁷⁄₁₆" (17.5 ×
21.5 cm). Abbott-Levy
Collection. Partial
gift of Shirley C. Burden

Page 38
Garry Winogrand
(American, 1928–1984)
Beverly Hilton. 1964.
13 1/16 × 8 3/4" (33.1 ×
22.2 cm). Purchase and
gift of Barbara
Schwartz in memory of
Eugene M. Schwartz

Page 39
Unknown
photographer
Untitled. August 1989.
Chromogenic color
print, 4 × 5 7/8" (10.1 x
14.9 cm). Gift of
Peter J. Cohen

Page 40
Brassaï
(French, born Romania.
1899–1984)
*A Morris Column in
the Fog, avenue de
l'Observatoire.* c. 1934.
11 × 7 15/16" (28 ×
20.3 cm). Gift of June
Sidman

Page 42
Clarence H. White
(American, 1871–1925)
Drops of Rain. 1903.
Platinum print, 7 5/8 ×
6" (19.4 × 15.2 cm).
Gift of Mrs. Mervyn
Palmer

Page 43

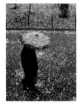

Hatsuo Ikeuchi
(Japanese)
Snowflakes. c. 1950.
14 × 10 3/8" (35.5 ×
26.3 cm). Gift of Nihon
Keizai Shimbun

Pages 44 and 45
Rudy Burckhardt
(American, born Switzerland.
1914–1999)
Untitled photographs
from the album
Afternoon in Astoria.
1940. Two prints,
2 3/4 × 4 3/8" (7 × 11.1
cm) and 3 9/16 × 3 1/16"
(9.1 × 7.8 cm). Gift of
CameraWorks, Inc.,
and purchase

Page 46
Unknown
photographer
Untitled. c. 1950.
2 11/16 × 2 1/2" (6.9 ×
6.3 cm). Gift of Peter J.
Cohen

Page 47
Eizi Kanbayashi
(Japanese)
Cold Day. c. 1950.
9 3/4 × 14" (24.8 ×
35.4 cm). Gift of Nihon
Keizai Shimbun

Page 49
Henry Wessel, Jr.
(American, born 1942)
*San Francisco,
California.* 1977. 9 7/8 ×
15" (25.1 × 38.1 cm).
Joseph G. Mayer Fund

Page 51
Stephen Shore
(American, born 1947)
*U.S. 97, South of
Klamath Falls, Oregon.*
July 21, 1973.
Chromogenic color
print, 17 3/4 × 21 15/16"
(45.1 × 55.7 cm).
The Photography
Council Fund

Page 52
John Szarkowski
(American, 1925–2007)
Sarah Lake. 1962.
7 7/16 × 9 5/16" (18.3 ×
23.7 cm). Promised
gift of Susan and
Peter MacGill

Page 53
Martin Parr
(British, born 1952)
*Lewes, Glyndebourne,
England.* 2008.
Pigmented inkjet print,
20 × 30" (50.8 ×
76.2 cm). Committee
on Photography Fund

Page 54

Henri Cartier-Bresson
(French, 1908–2004)
*Alberto Giacometti
Going Out for
Breakfast, Paris.* 1963.
23 1/8 × 15 9/16"
(58.7 × 39.6 cm). Gift
of the artist

Page 58
Lee Friedlander
(American, born 1934)
New York City. 1965.
6 1/4 × 8 13/16" (15.8 ×
22.4 cm). Purchase

Back cover:
Weegee
(American, born Austria.
1899–1968)
Untitled (Upper West
Side, New York).
c. 1945. 10 7/16 × 13 7/16"
(26.5 x 34.2 cm).
Promised gift of
Robert B. Menschel

Credits

This book is made possible by The John Szarkowski Publications Fund.

Produced by the Department of Publications
The Museum of Modern Art, New York
Christopher Hudson, Publisher
Chul R. Kim, Associate Publisher
David Frankel, Editorial Director
Marc Sapir, Production Director

Edited by Chul R. Kim
Designed by Beverly Joel, pulp, ink.
Production by Hannah Kim
Photograph research by Tasha Lutek
Printed and bound by Ofset Yapimevi, Istanbul

This book is typeset in Avenir and Sentinel.
The paper is 115 gsm Magno Volume.

Library of Congress Control Number: 2016946548
ISBN: 978-1-63345-014-1

Distributed in English by Abrams Books for
Young Readers, an imprint of ABRAMS, New York

Printed in Turkey